fantomorphia

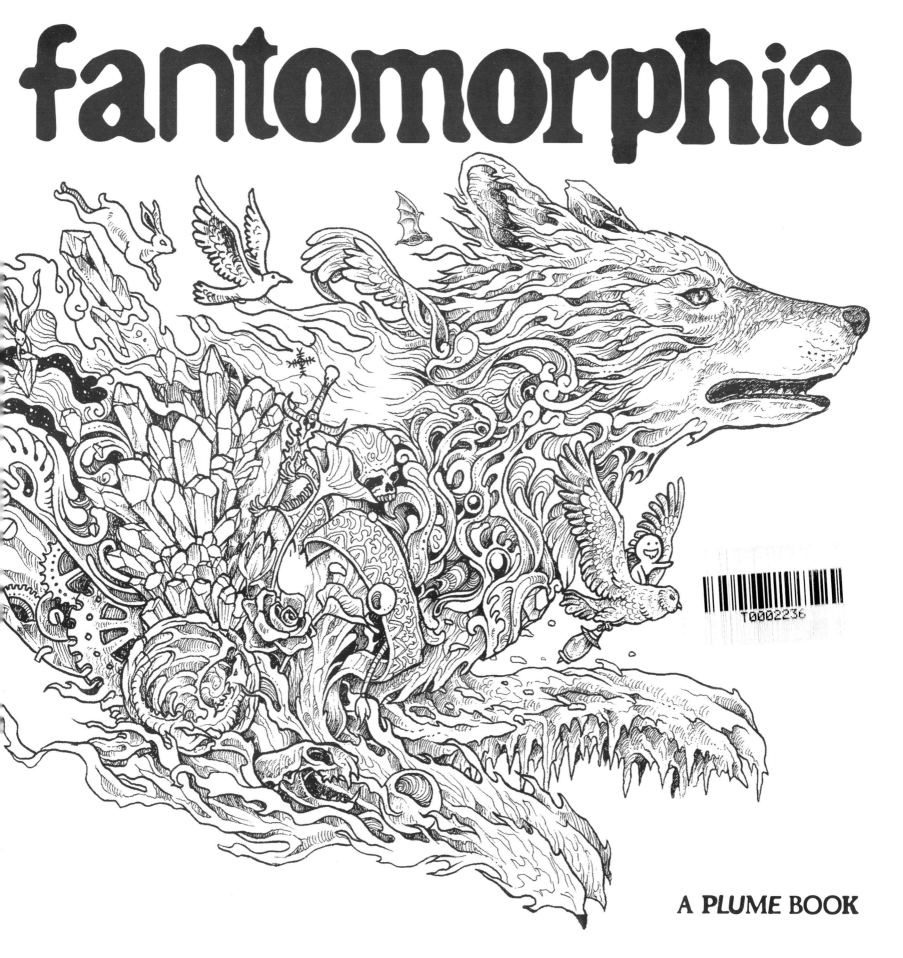

A **PLUME** BOOK

Illustrated by

Kerby Rosanes

This book belongs to

...

Edited by Hannah Daffern
and Lauren Farnsworth
Designed by Derrian Bradder
Cover Design by Angie Allison

With thanks to Harry Thornton
for being a great talent scout

PLUME

An imprint of Penguin Random House LLC
375 Hudson Street
New York, New York 10014

First published in Great Britain in 2018 by
LOM ART, an imprint of Michael O'Mara Books Limited,
9 Lion Yard, Tremadoc Road, London SW4 7NQ

W www.mombooks.com

f Michael O'Mara Books

@OMaraBooks

ISBN 9780525536727

Printed in the United States of America
5th Printing

Explore this fantastical coloring adventure!

Dive into my high-definition, super-detailed doodle world where dreamscapes and fantasy become reality and seem to morph from your wildest imagination.

Each detailed drawing has been crafted with fineliner pens and can be colored in any way you like.

Keep your wits about you to find search objects scattered throughout the pages. You'll find a list of these hidden gems at the back of the book, so you know exactly what to look for, along with all the answers.

Kerby Rosanes

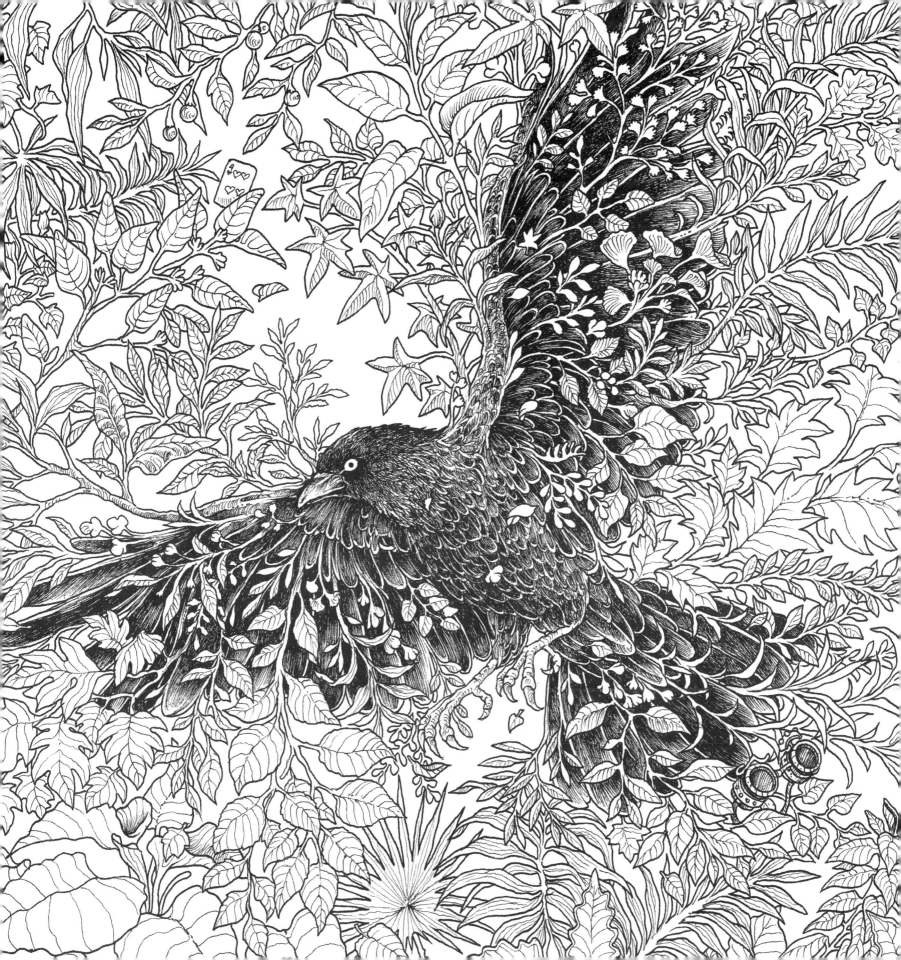

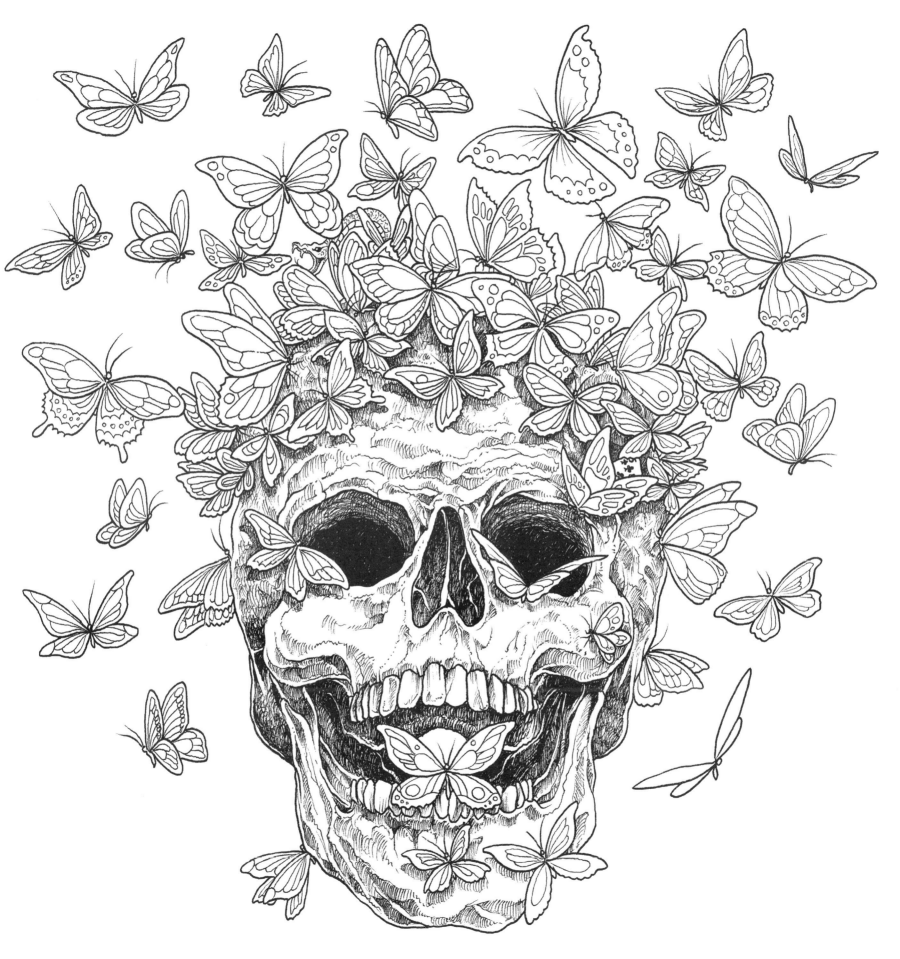

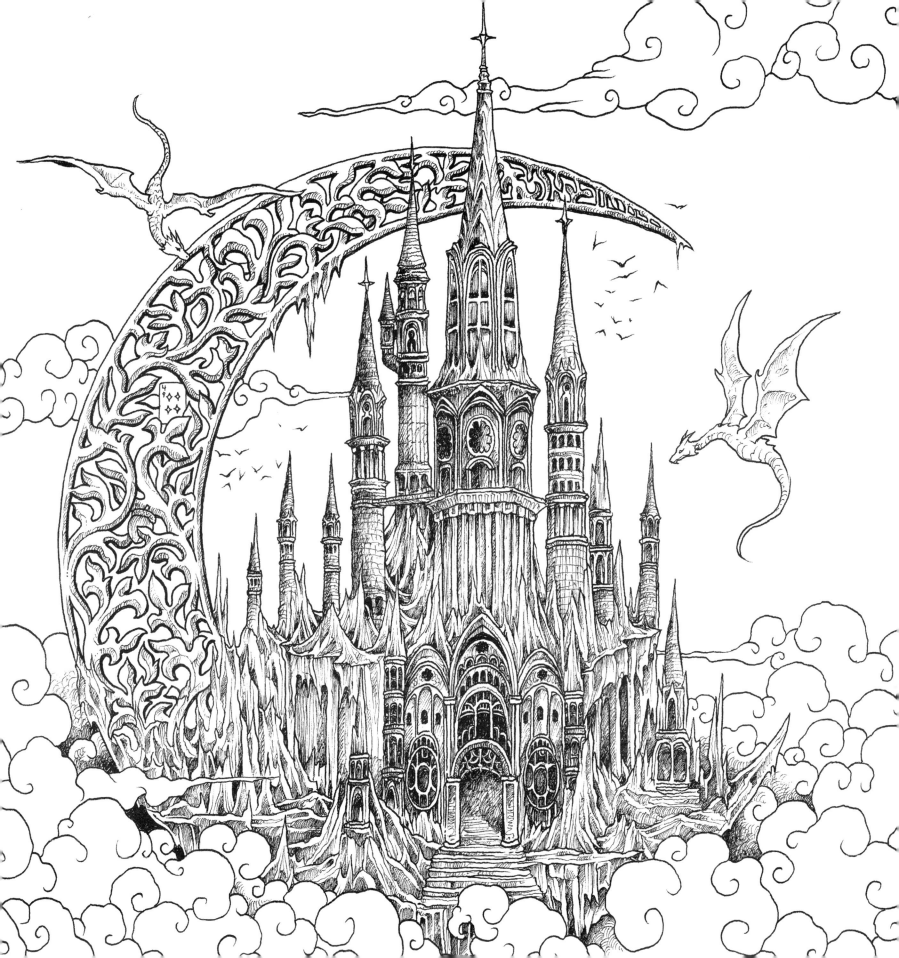

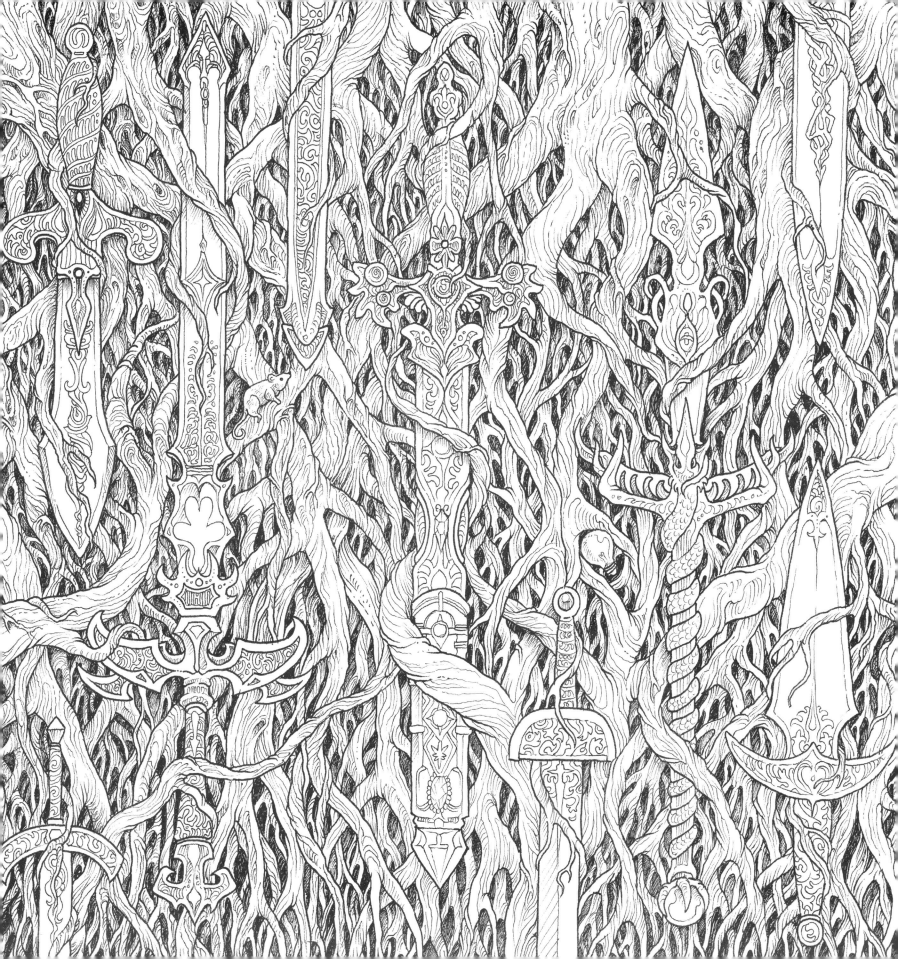

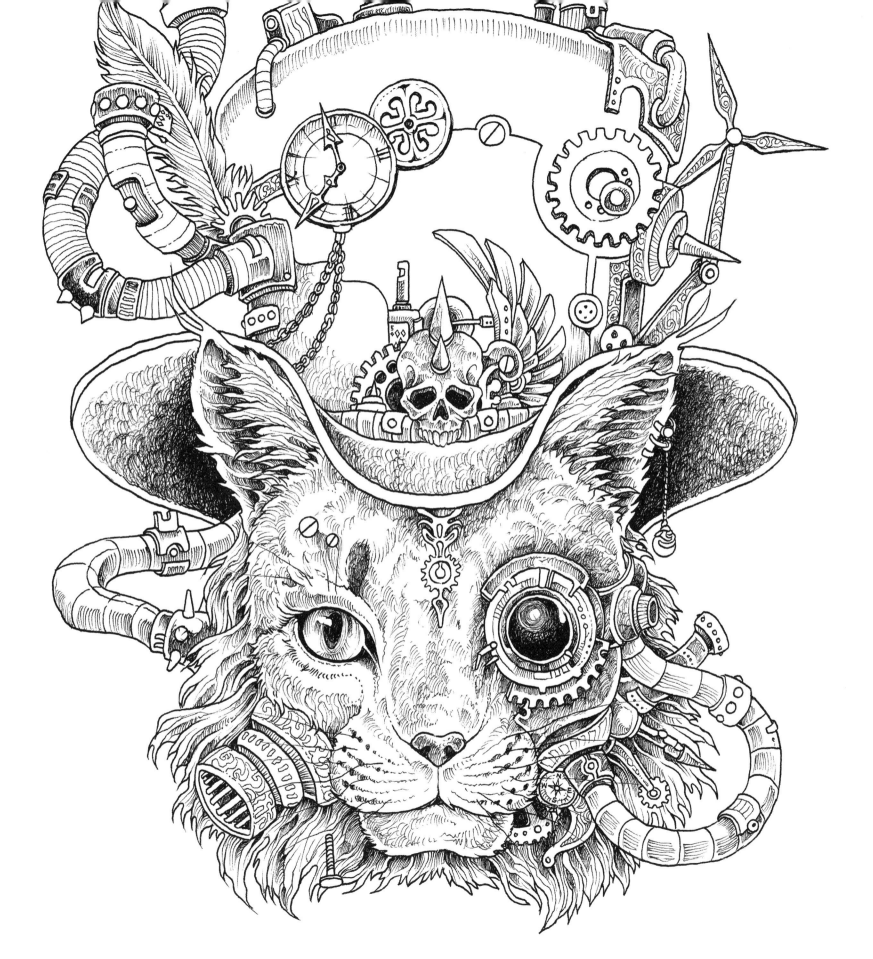

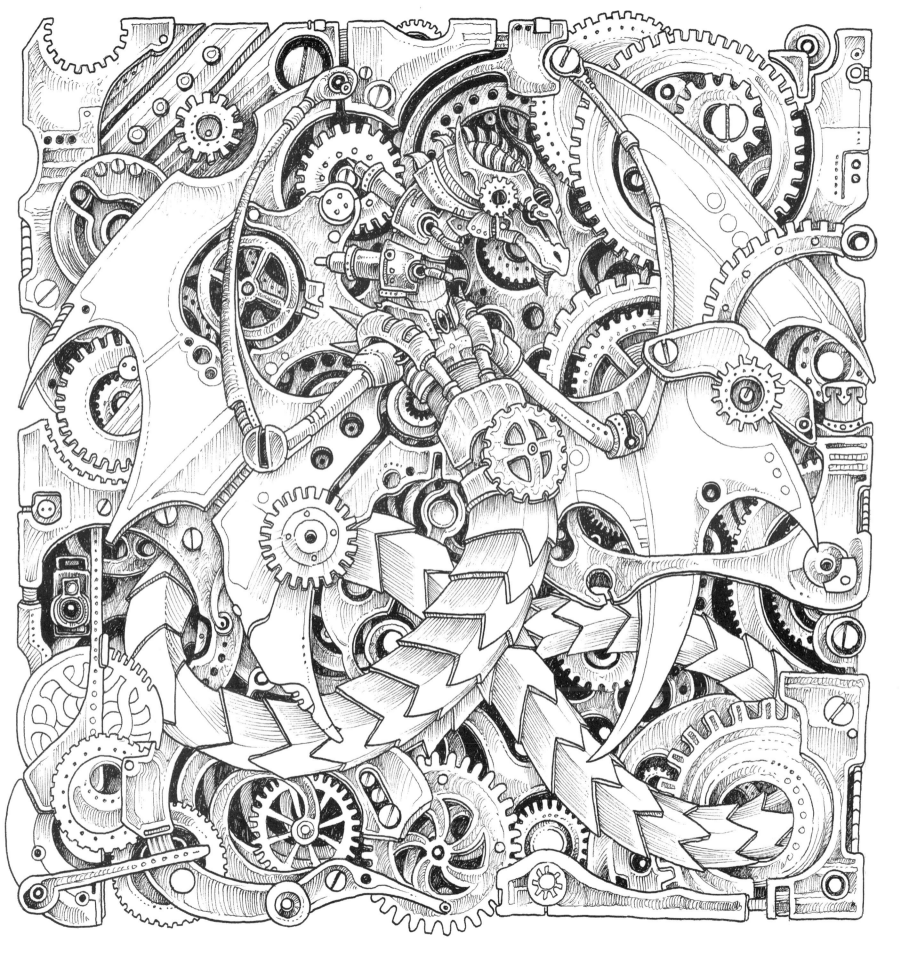

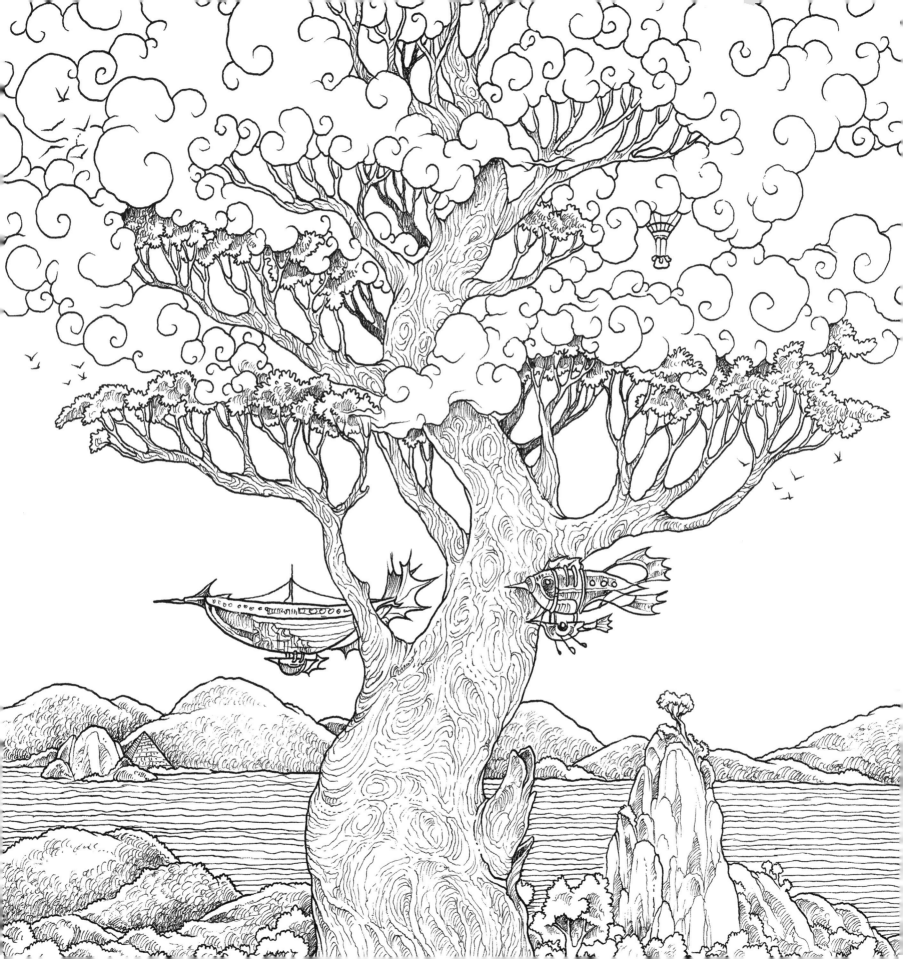

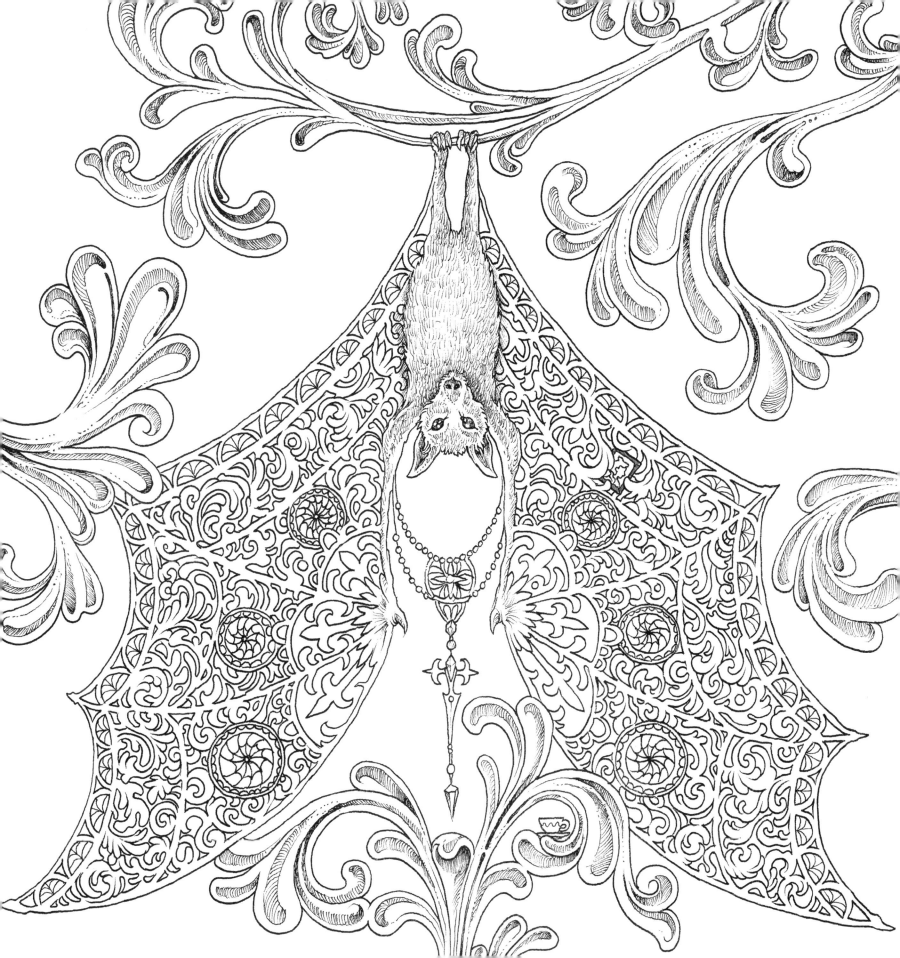

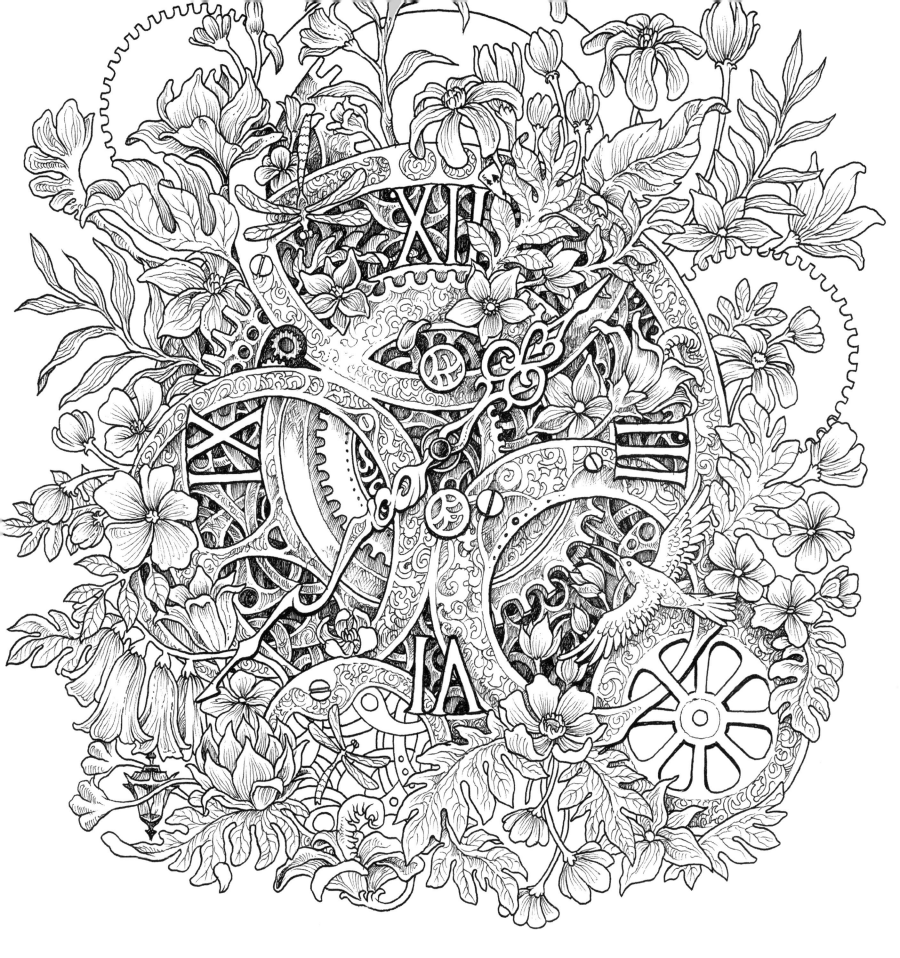

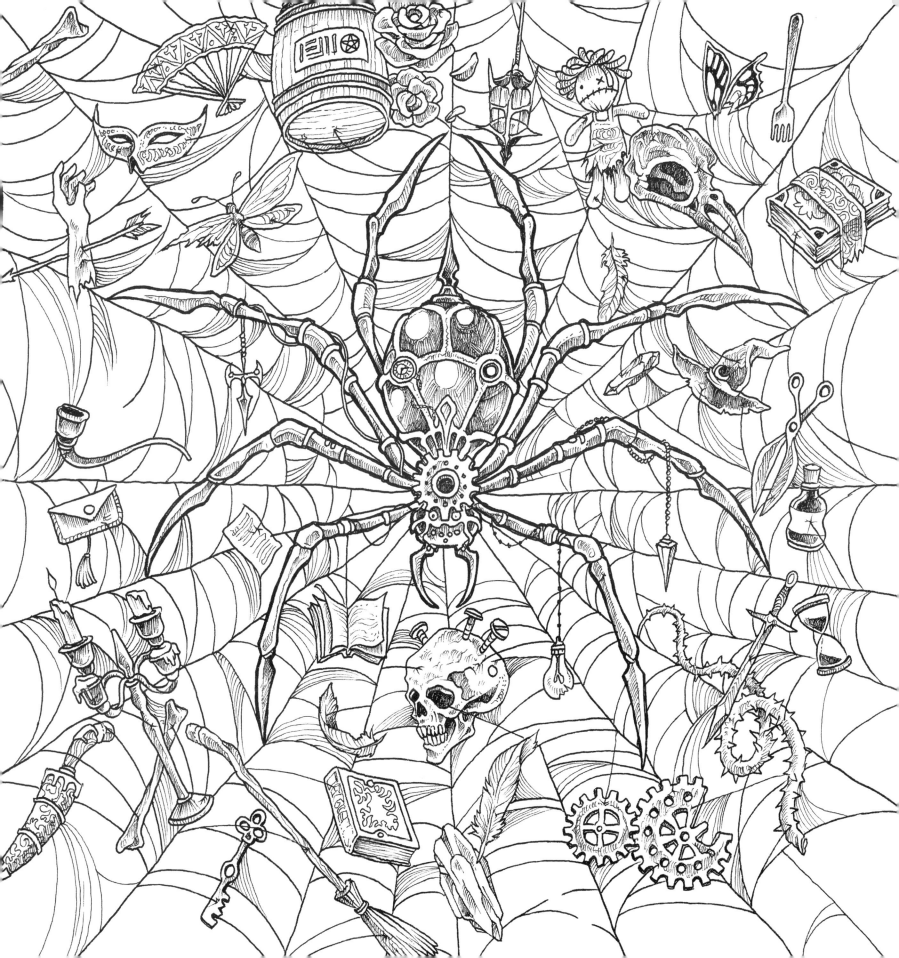

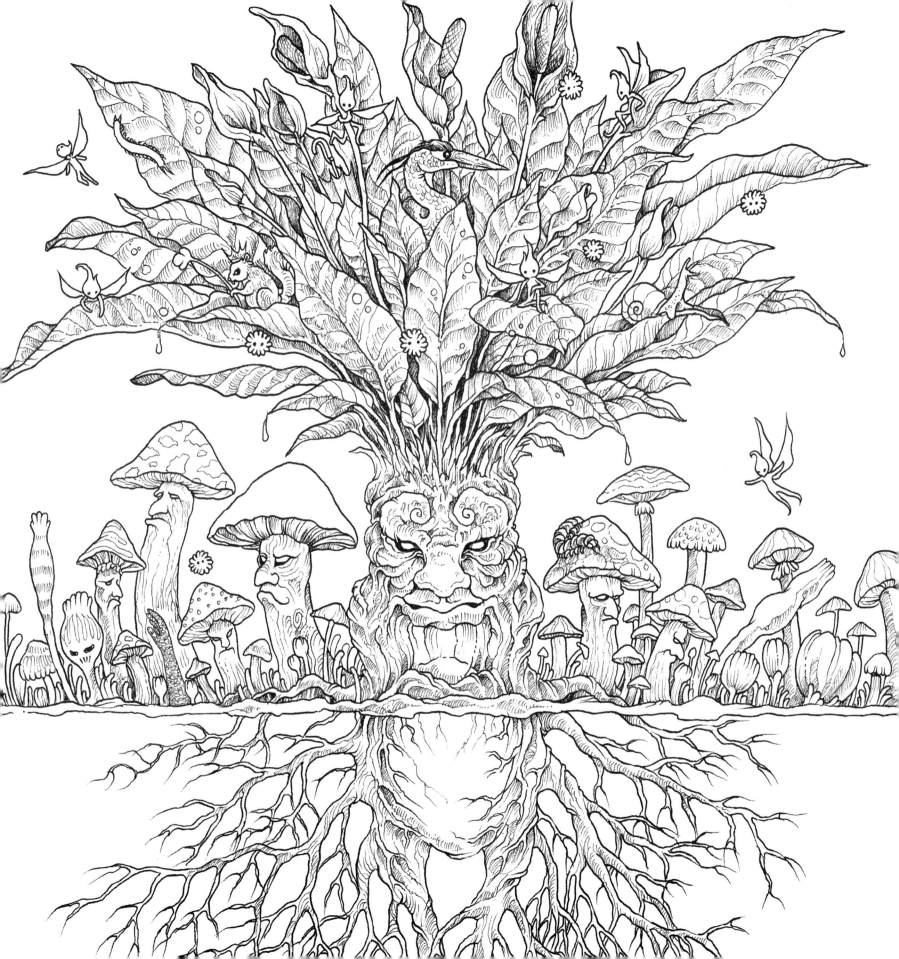

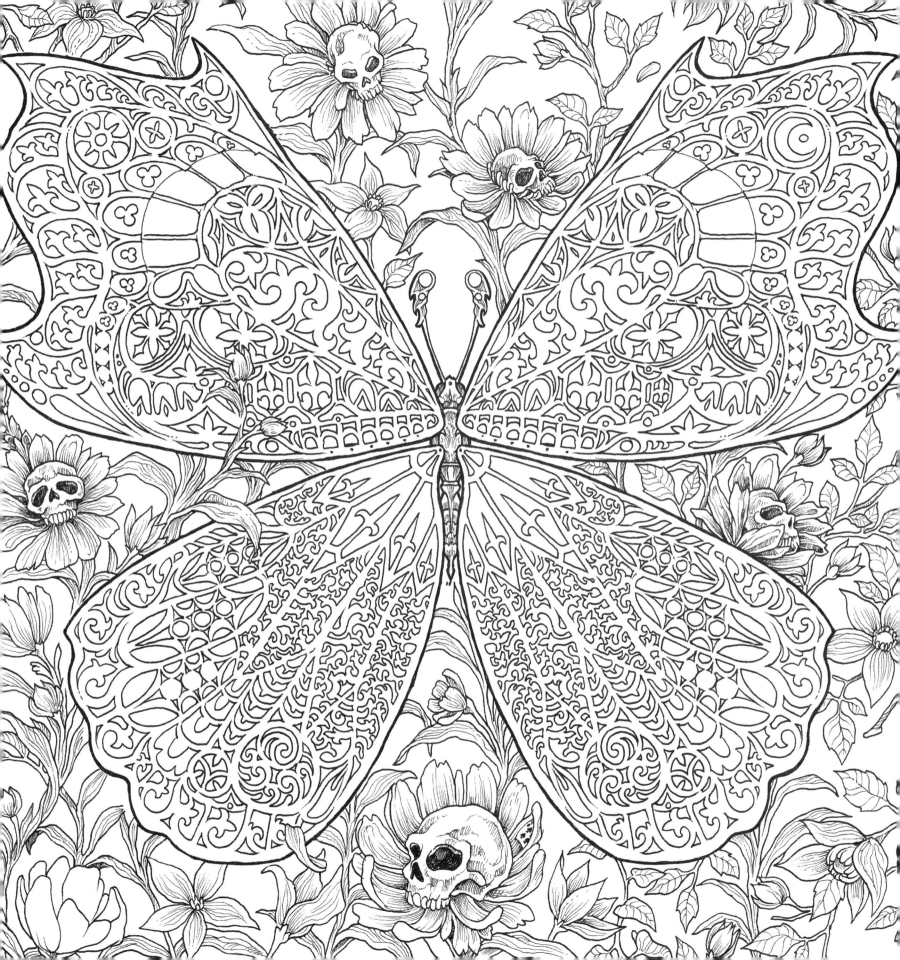

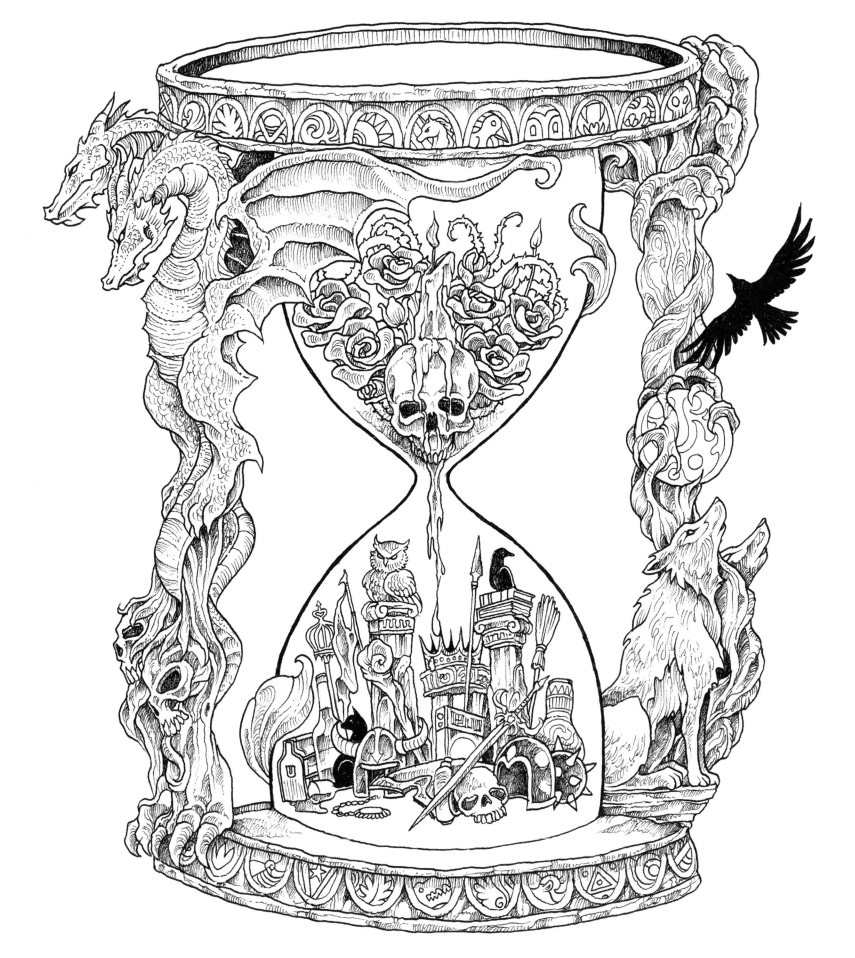

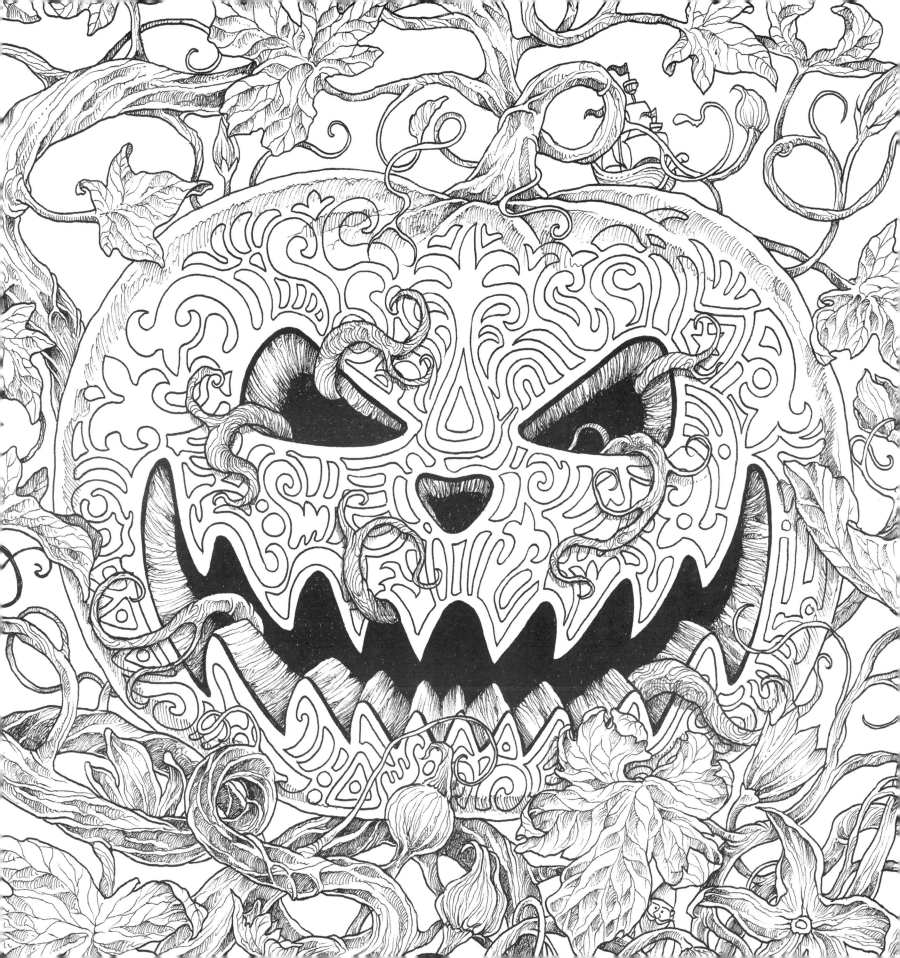

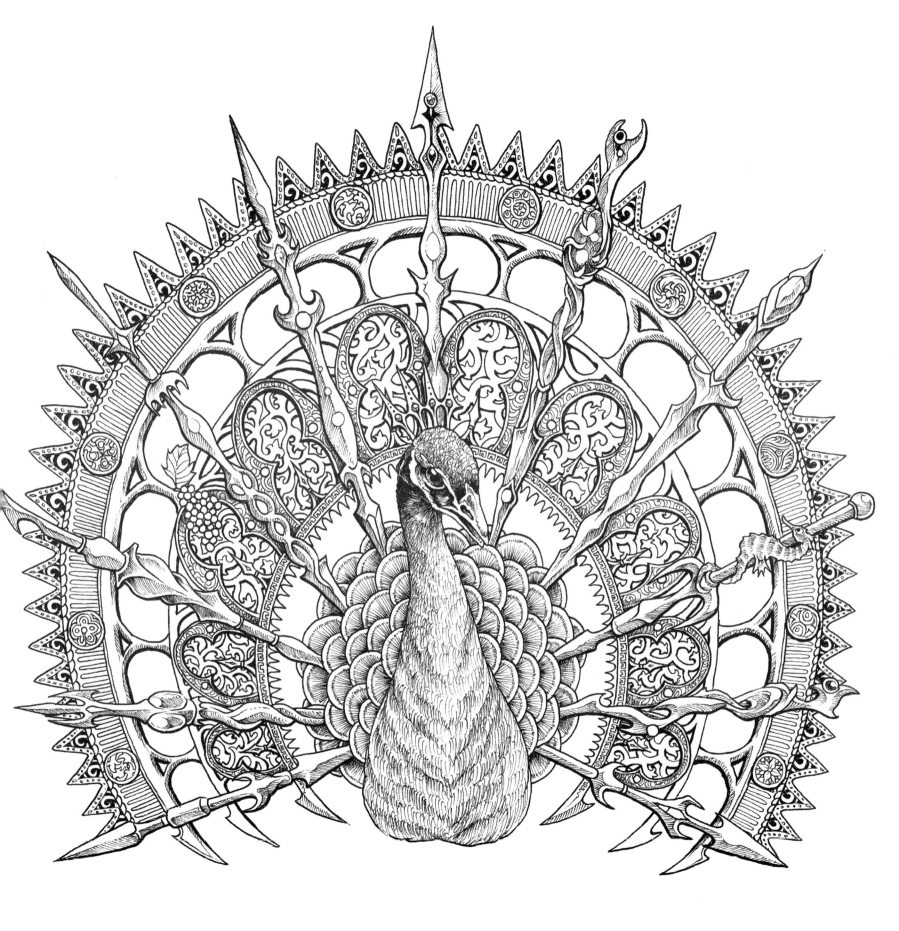

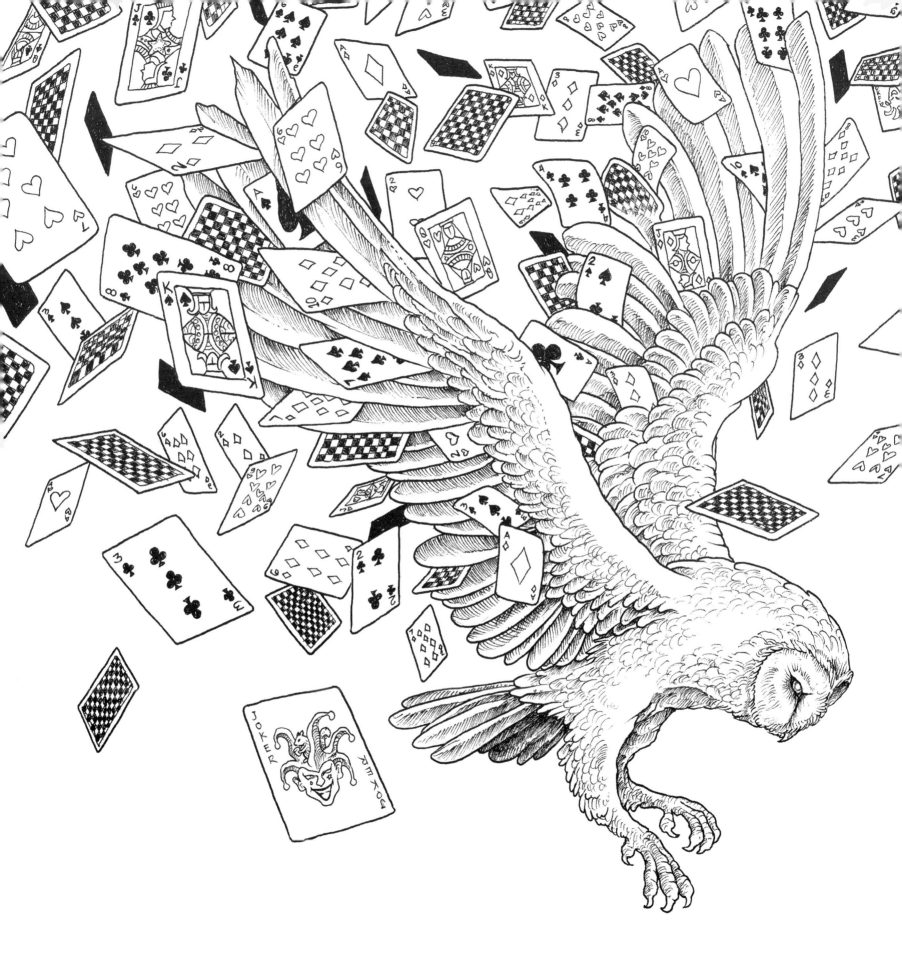

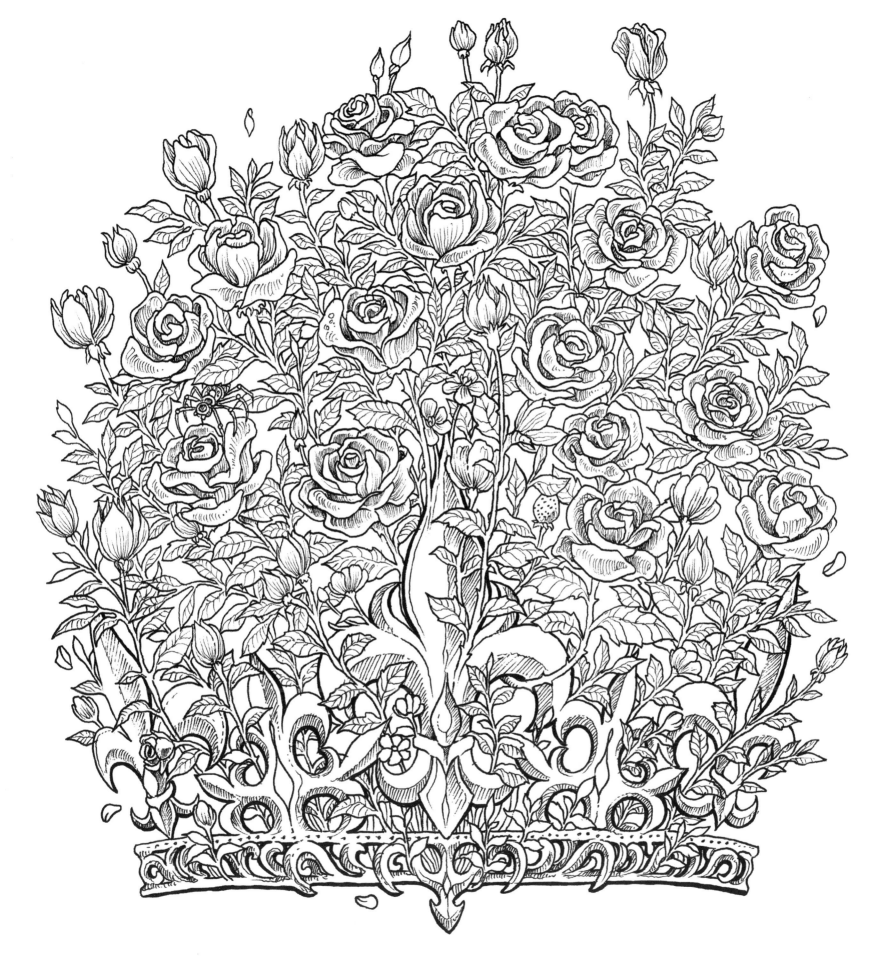

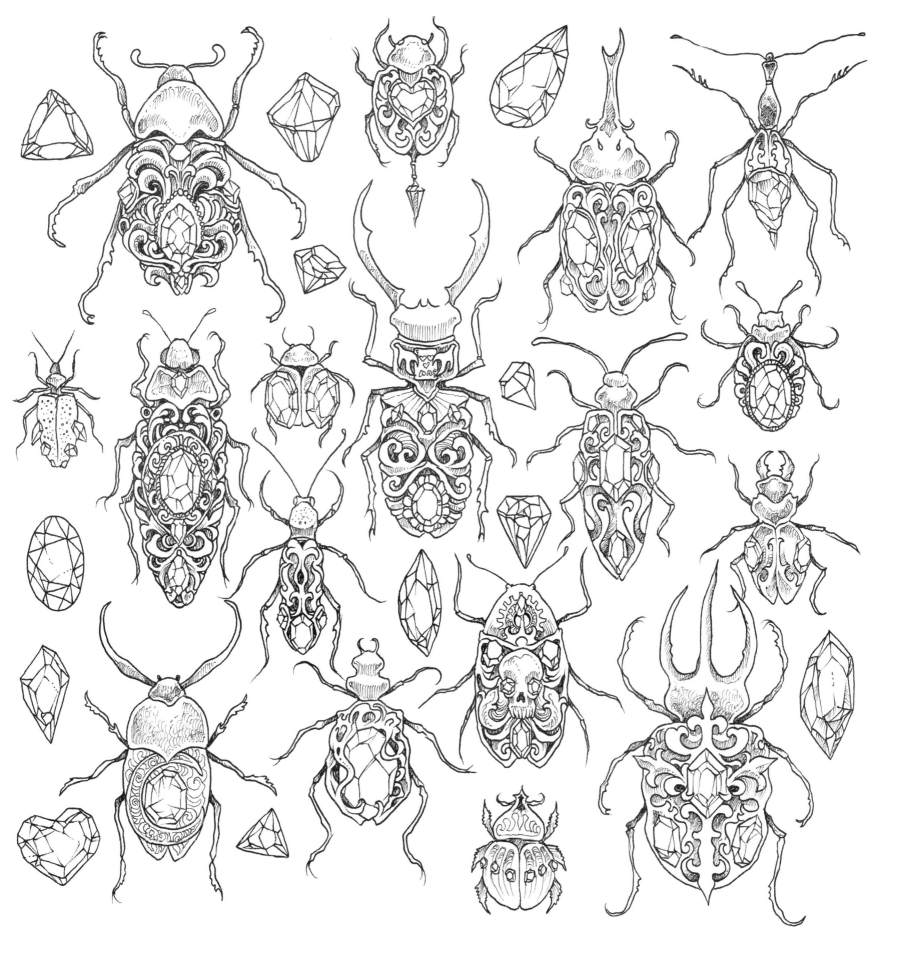

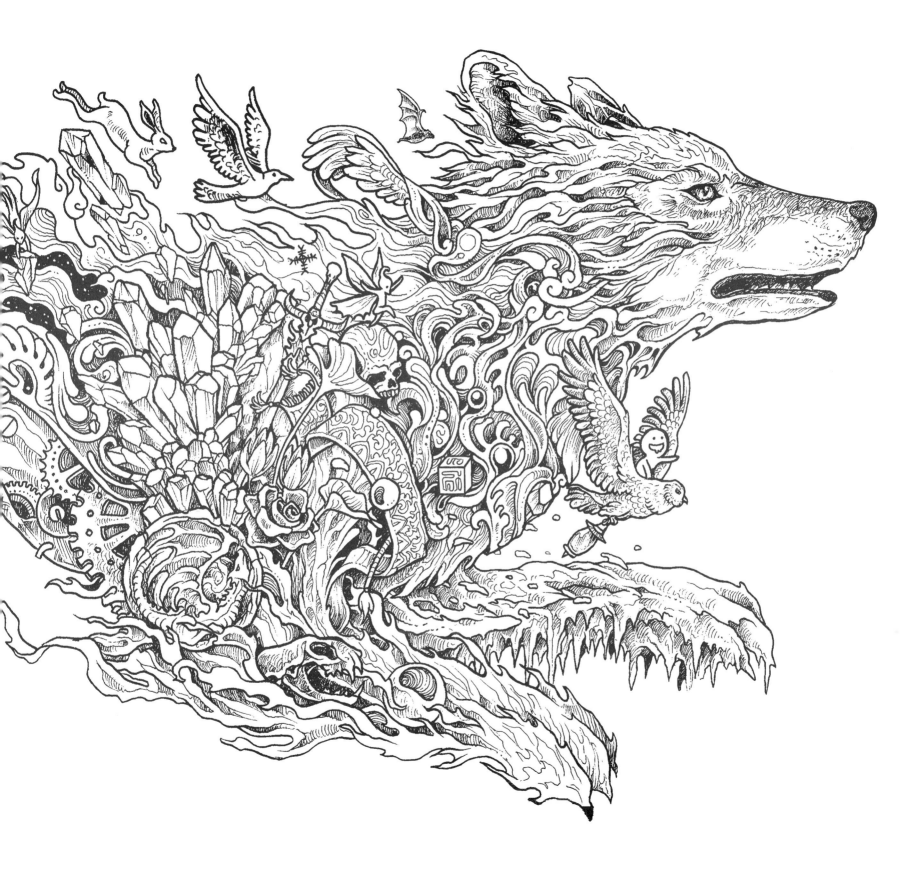

Can you find these items, artifacts, and creatures in the book?

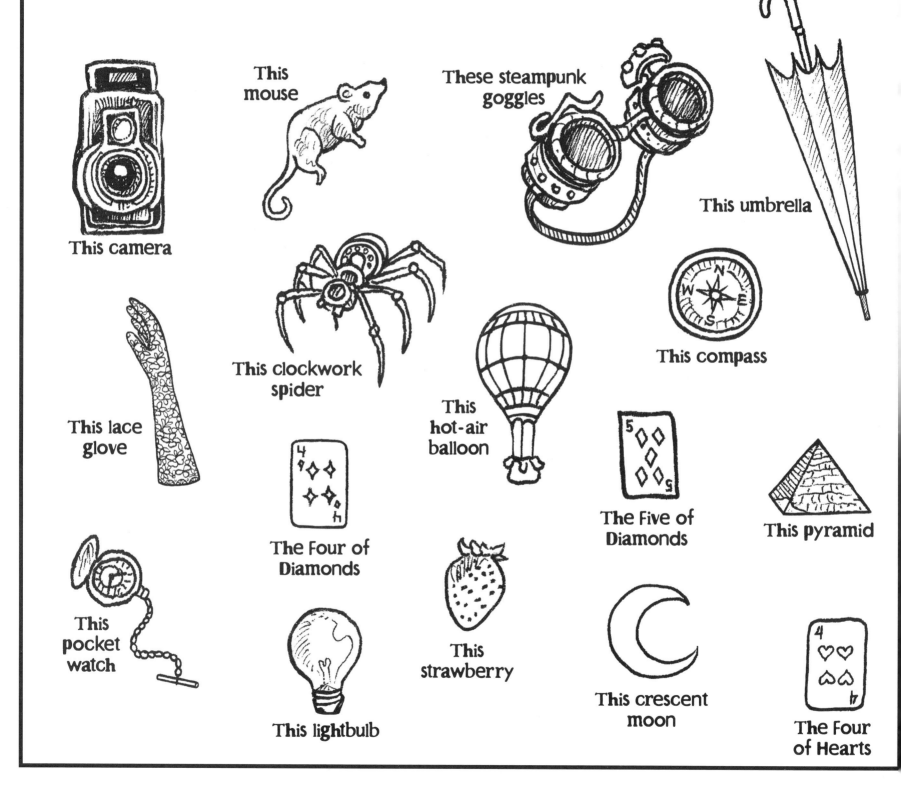

This camera

This mouse

These steampunk goggles

This umbrella

This lace glove

This clockwork spider

This hot-air balloon

This compass

This pocket watch

The Four of Diamonds

This lightbulb

This strawberry

The Five of Diamonds

This pyramid

This crescent moon

The Four of Hearts

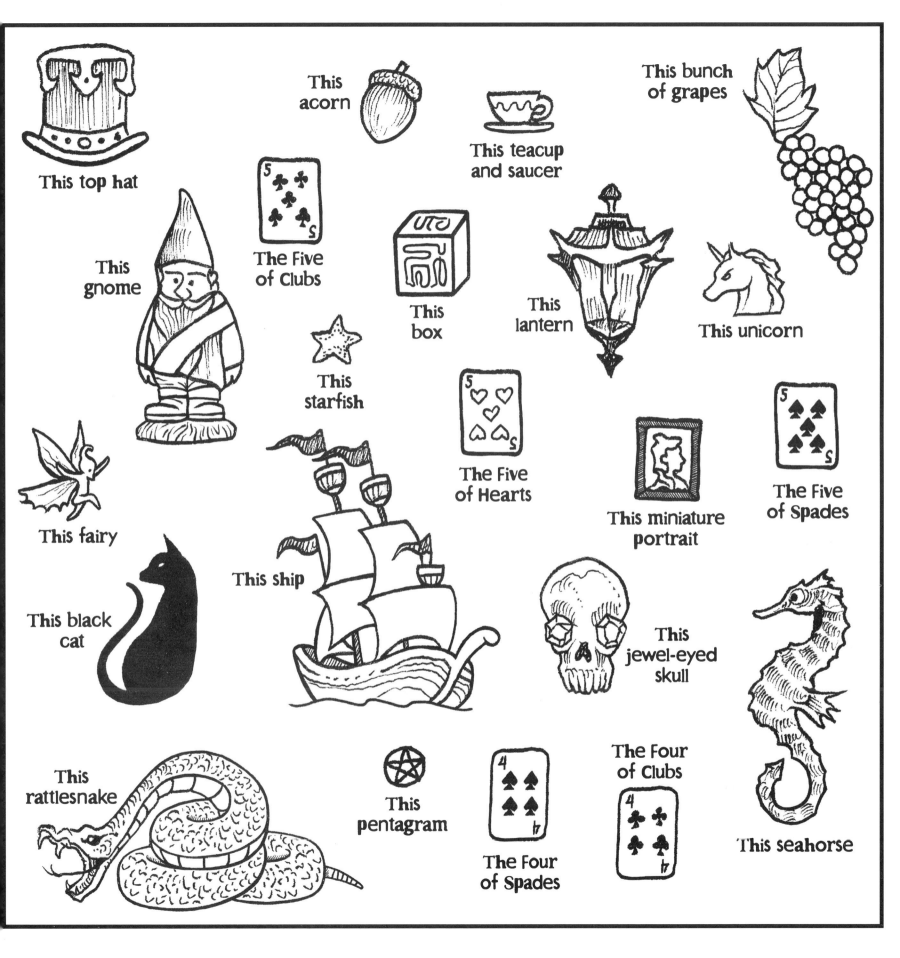

This top hat

This acorn

This teacup and saucer

This bunch of grapes

This gnome

The Five of Clubs

This box

This lantern

This unicorn

This starfish

The Five of Hearts

This miniature portrait

The Five of Spades

This fairy

This ship

This black cat

This jewel-eyed skull

This seahorse

This rattlesnake

This pentagram

The Four of Spades

The Four of Clubs

All the Answers

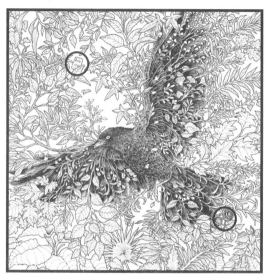

Steampunk goggles
and the Four of Hearts

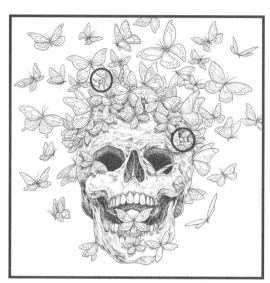

A rattlesnake and the Five of Clubs

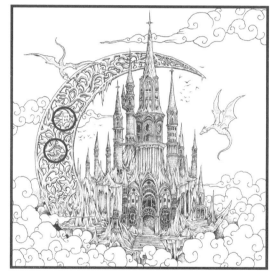

An acorn and the Four of Diamonds

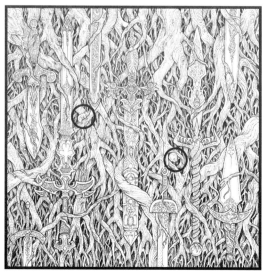

A lightbulb and a mouse

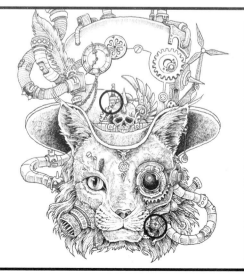

A compass and the Five of Diamonds

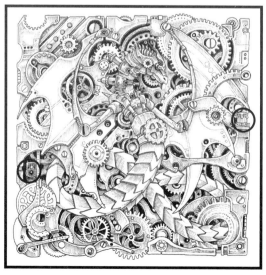

A camera and a top hat

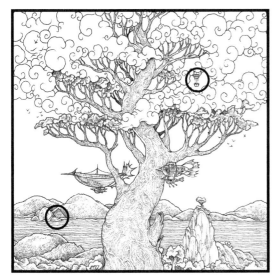

A pyramid and a hot-air balloon

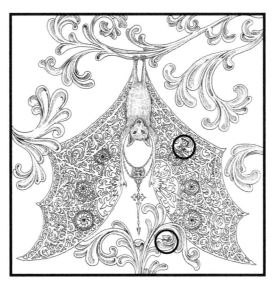

A miniature portrait
and a teacup and saucer

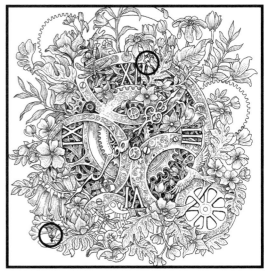

A lantern and the Five of Spades

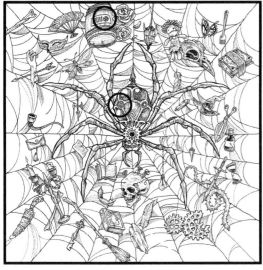

A pocket watch and a pentagram

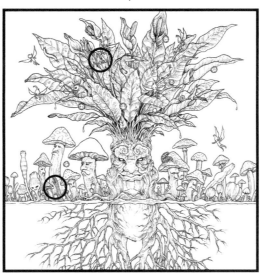

A lace glove and an umbrella

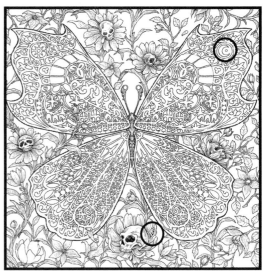

A crescent moon
and the Four of Spades

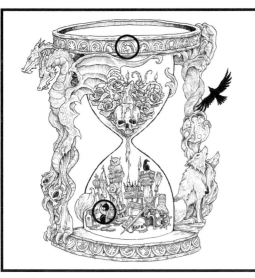

A unicorn and a black cat

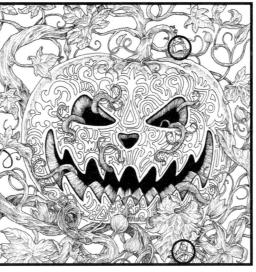

A gnome and a ship

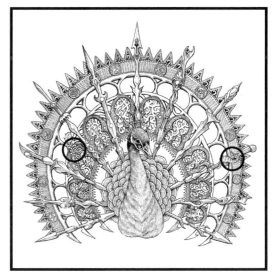

A bunch of grapes and a seahorse

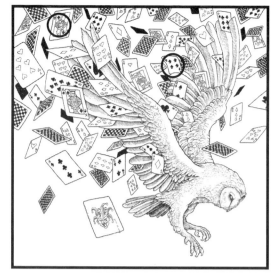

A starfish and the Four of Clubs

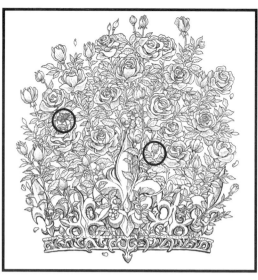

A clockwork spider
and a strawberry

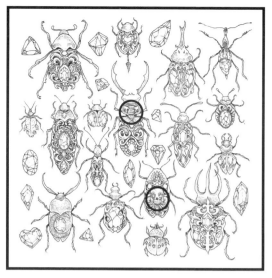

A jewel-eyed skull
and the Five of Hearts

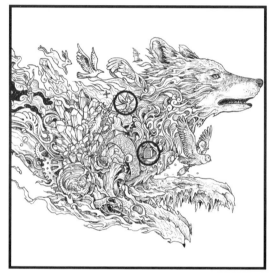

A box and a fairy

The end

Share your creations:
#fantomorphia